REBECCA HORN

Lumière
Light
en prison
imprisoned
dans
in
le ventre
the belly
de la baleine
of the whale

HATJE CANTZ

**Rebecca Horn: Lumière en prison dans le ventre de la baleine /
Light imprisoned in the belly of the whale**
Palais de Tokyo site de création contemporaine
Festival d'automne à Paris
November 28, 2002 – January 12, 2003

English translation: George Frederick Takis and Rebecca Horn
French translation: Laure Bernardi and Rebecca Horn
Design: Hans Werner Holzwarth, Berlin
Photographs: Heinz Hefele, Darmstadt
Lithography: C + S Repro, Filderstadt
Production: Dr. Cantz'sche Druckerei, Ostfildern-Ruit
© 2003 Rebecca Horn
© 2003 for the poem *LUMS (lumière):* Jacques Roubaud
© 2003 for this edition: Hatje Cantz Verlag, Ostfildern-Ruit

Published by:
Hatje Cantz Publishers
Senefelderstrasse 12, 73760 Ostfildern-Ruit/Germany
Tel. 00 49/7 11/4 40 50, Fax 00 49/7 11/4 40 52 20
www.hatjecantz.de
First edition 2003
ISBN 3-7757-9136-1
Printed in Germany

In 1997 Jacques Roubaud wrote fifty-three poems for Rebecca Horn. Inspired by this poetry, Rebecca Horn created sculptures of light. Words wander through the dark space, weave through the murkiness, forming an intertwined network, a firmament of text. In a bath of black water the poems reflect each other, dissolving within the waves, and new signs arise. A song in dialogue with a whale, composed and performed by Hayden Danyl Chisholm, accompanies these transformations.

En 1997 Jacques Roubaud a écrit cinquante trois poèmes pour Rebecca Horn. De cette œuvre, Rebecca Horn a créé des sculptures de lumière. Les mots errent dans l'espace obscur, le pénètrent, forment un réseau de mailles serrées et entrelacées, un firmament de texte. Les poèmes se miroitent dans un bain d'eau noire, se dissolvent dans les ondes et de nouveaux signes apparaissent. Un chant dialogué avec la baleine, composé et interprété par Hayden Danyl Chisholm, accompagne ces transformations.

Racines horizontales;

Horizontal roots,

Ramifications des ailes-branchies

ramifications of gill-wings

suçant le sang froid

suckled on cold blood.

Infiniment seule dans les corridors glissants.

Endlessly alone in slippery corridors,

Formes de l'air, formes de la lune

shapes of air, shapes of moon,

Où s'accrocher dans ce flux ?

in all this floating where to hold on?

Faire jaillir le feu en frottant le corps

Rubbing the body, to create a fire

dans l'hôtel des mots à naître,

in the hotel of unborn words,

Bessie Love à Paris, 1928.

Bessie Love in Paris, 1928.

REBECCA HORN

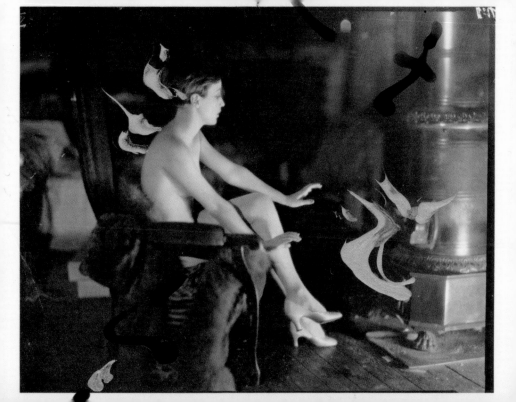

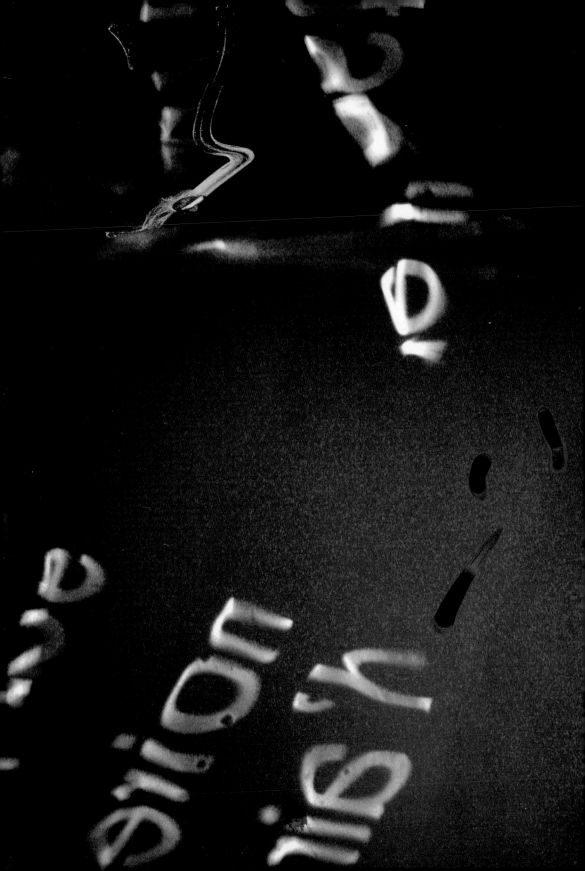

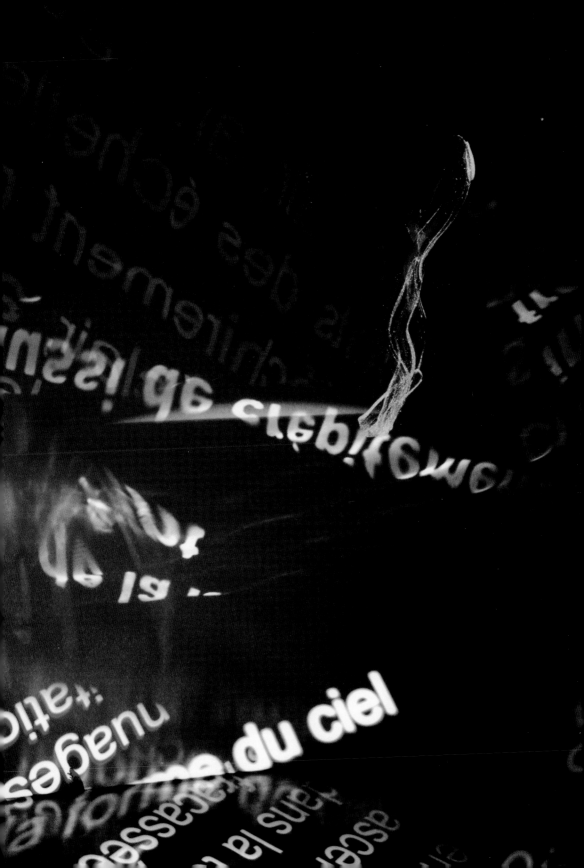

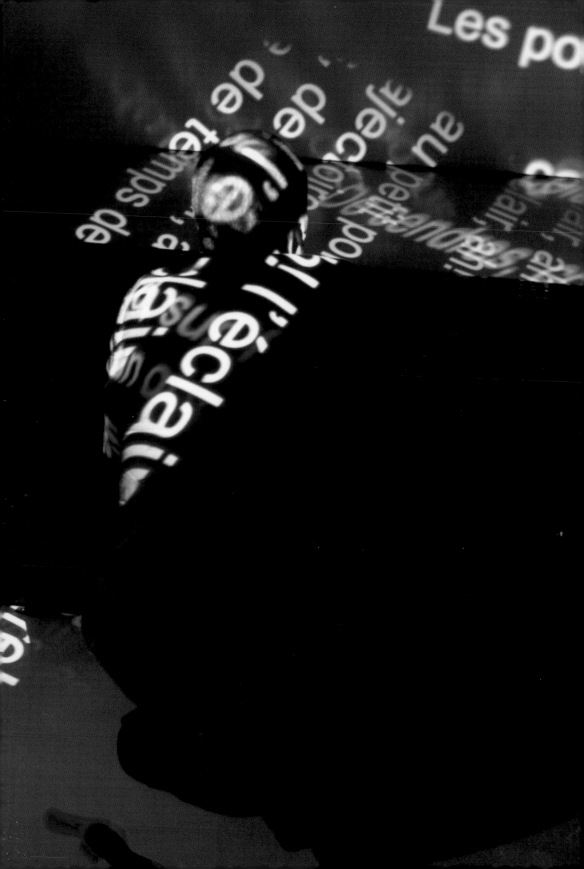

éclair

bleu de l'éclair, ah!

remblements des éche

impétueux déchirement

froissement de l'éclair, a

rosiarès ascendants de l'

ttentes dans la terre d

fractions fracas

ussin

les pores des

de nuages

Les mots errent dans la nuit,

In the night words are wandering

ombres à l'intérieur de la tête

like shadows inside the head,

glissant sur le marbre de l'eau.

gliding across the marble of water.

Un bâton d'or interrompt ce flux,

A golden rod interrupts the flow,

écrire à contre-courant dans l'eau noire,

writing in reverse upon black water,

délivrer les phrases dans les vagues,

redeems sentences through waves,

mener une danse folle de signes

kindles a turmoil of signs

dans la transparence miroitante.

in mirrored transparency.

Tremblant, les mots se recomposent

Trembling words search for a new order,

Demandant leur chemin à la lune

asking the moon for orientation

Dans ce dôme de mots entrelacés.

in the dome of interwoven words.

REBECCA HORN

l'éclair

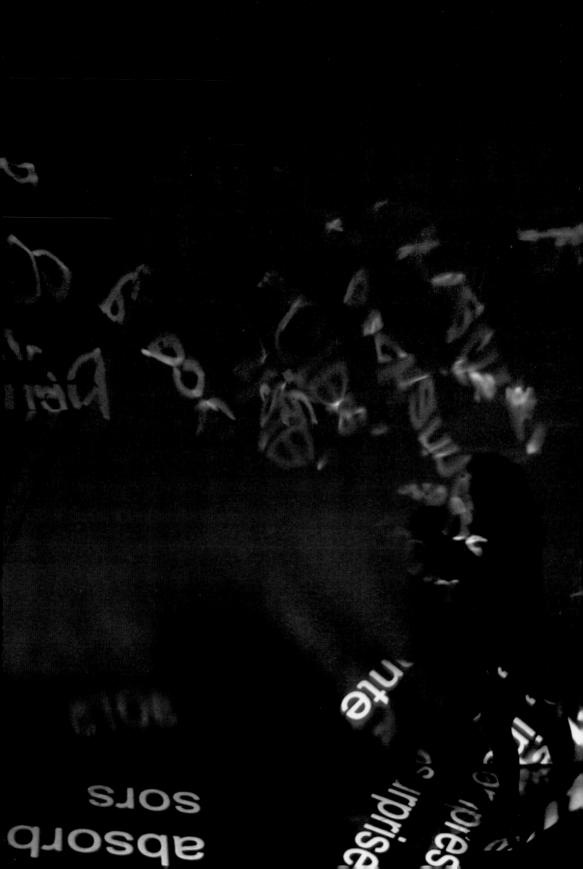

L'éphémère éclair
Arrêtèe dans l'iné

phémere.

Arrêtée dans l'inévita...
concavité du tombeau
- ce qui fait qu'on ignore...
l'éphémère est sans épais...
mais sphérique

Square

squar...

Fuir ce ventre d'échos ramifiés

Escape from the belly of ramified echoes,

Encercler le cœur battant de la baleine.

whirling around the heart-pulse of the whale.

Mon ombre invente sa fièvre,

My shadow invents its fever,

égorge la pulsation froide,

clasps the cold throb,

envoie des flammes de lumières

sending flames of light

jusque dans le centre du cœur.

in the center of the heart.

On ne sait pas si l'amour

Uncertain if love contains

dans ce feu cache sa délivrance.

deliverance within the fire.

REBECCA HORN

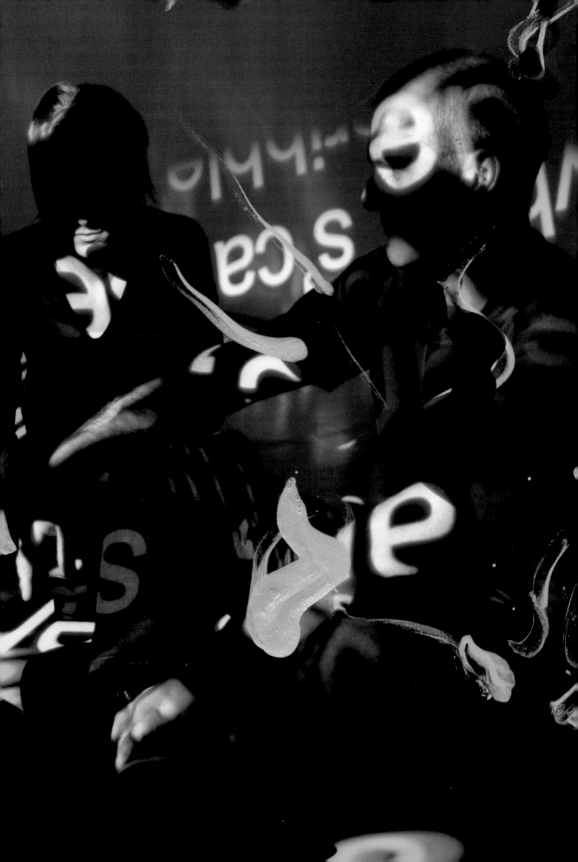

Les p

éfractions fracass

attentes dans la te

pores des arbres ans l'in

éphémè

Alerêtées sobre

sol cé du

cel

le temps

temps de feu

l'air l'enveloppe

douce

mais morte

c'est tout

mais

rbes

sque poires,

res,

ntier des signe

me de nulle

oires bleu

sans l'inévitable

qu'on ignore la forme du ciel

re est sans épaisseur

du tombeau

chiff

La semence du mot

The grain of seed in the word,

nourrie dans l'ombre,

nourished in darkness,

ne sait pas lacer le nœud du cœur

unable to fasten the heart-knot,

c'est la lumière et l'ombre en même temps,

is light and shadow at once,

suspendues dans la sphère.

floating in the sphere.

Une goutte d'air et d'eau

A drop of air and water

se forme dans le ventre de la baleine

takes shape within the whale

et devient cri.

as a scream.

Naissance du mot,

Birth of words,

dont l'écho effleure les vagues

resounding across the waves,

et coule vers le soleil.

gliding towards the sun.

REBECCA HORN

ir, ah! l'éclair

ah! l'éclaire!

ah! l'éclaire!

l'éclaire!

l'éclaire!

l'éclaire!

ah! l'éclaire!

ah! l'éclaire!

ah! l'éclapore

de la pass

De cendres

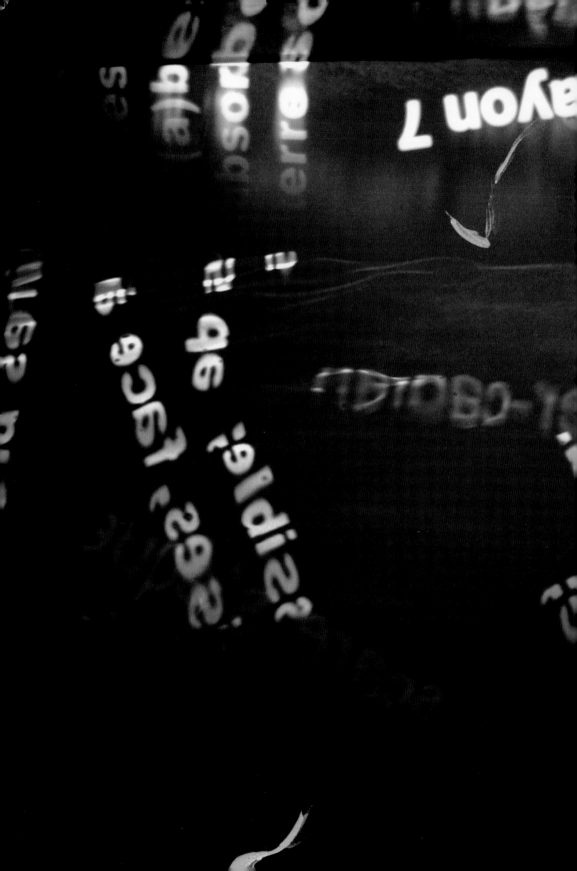

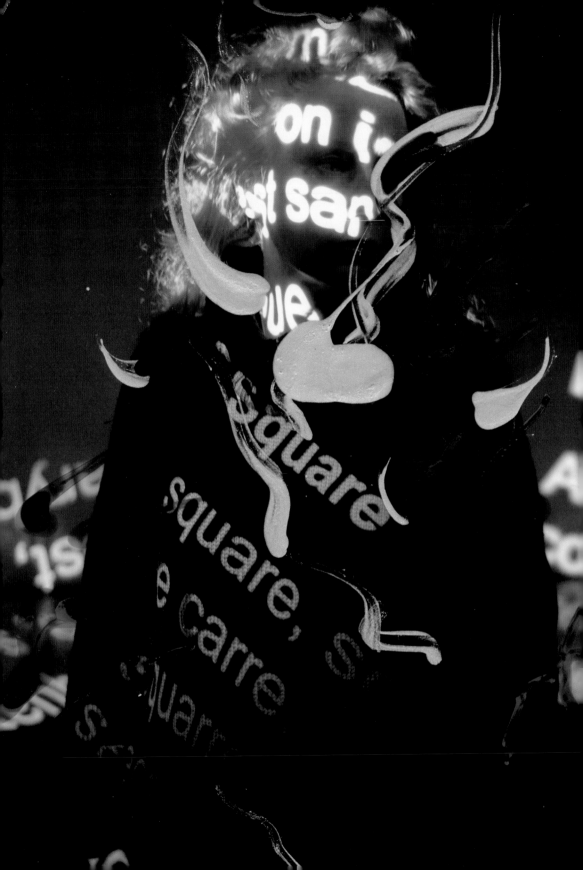

Les por

acculées, accou

la lumière suspendue

il ni la feuille, l'air

coupes rachués, des rues

plus qu'une

arbres, so

pores des arbres,

lessel caché

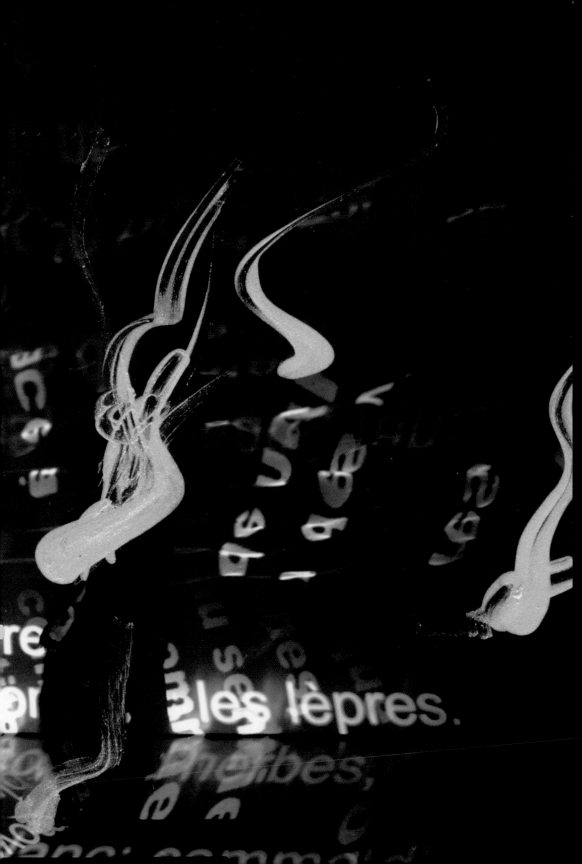

JACQUES ROUBAUD

LUMS

(LUMIÈRE)

dérivée première: poème

septembre 2002

..............................

..............................
..............................
..............................

triangle de bleu dans le bas d'un œil vert
..............................
..............................
..............................
..............................
..............................
..............................
..............................
..............................

..............................
..............................
..............................
..............................

..............................

..............................
..............................
..............................

remonté sur le crotchless rose
..............................
..............................
..............................

..............................
..............................
..............................
..............................
..............................

douce
mais morte

..............................
..............................
"au sentier des vignes" "moi
"l'homme de nulle part"
..............................
..............................
..............................
..............................
..............................

..............................
..............................
..............................

..............................
..............................
..............................

..............................
..............................
..............................

..............................
 la lumière suspendue, incompressible;

..............................
... la fontaine
sentait la neige
..............................
..............................
..............................
..............................
..............................
..............................
..............................
..............................
..............................
..............................
..............................
..............................
..............................

......................................
......................................

 La lune ne répondit pas

.....................................
.....................................
.....................................

.....................................
.....................................
.....................................

.....................................

.....................................
.....................................
.....................................
.....................................
.....................................

.....................................

.....................................
.....................................
.....................................

..éphémère sans épaisseur
mais sphérique

.....................................
.....................................
.....................................
.....................................
.....................................

 rosaires ascendants de l'éclair, ah! l'éclair!
.............................
.............................
.............................
.............................

..................................

..................................
..................................
..................................

..................................
..................................

..................................

..................................

..................................
..................................

..................................

..................................

nuit, et silence, et silence; silence.

..................................

..................................
..................................

..................................
..................................

..................................

..................................

..................................

.................................

.................................

.................................
.................................
.................................
.................................
.................................
.................................
Les flaques
Noires
.................................

Le bruit des étoiles se produit entre les yeux.

.................................

.................................

.................................

.................................
.................................
.................................
.................................

.................................
.................................
.................................
.................................

il se fait bleu

.....................................
.....................................
tais l'âme. partout où. tout le corps. partout où. au plus ceci. la durée. partout où.
au contraire l'âme.
.....................................

.....................................
.....................................
.....................................

.....................................
.....................................
.....................................

.....................................
.....................................
.....................................
.....................................

.....................................
.....................................
.....................................
.....................................
.....................................
.....................................
.....................................
Le plafond des chambres est rouge aujourd'hui

.....................................

.....................................

square
.............................
.............................secret,
.............................
.............................
.............................

..............................
..............................
..............................
..............................
..............................
..............................
..............................
nous,
..............................nimmer,

..............................
..............................never, never

..............................
..............................
..............................
..............................
..............................
..............................
blanc loin soleil.
tout.

..............................
..............................
..............................
..............................
..............................
..............................
..............................
..............................
..............................
..............................
..............................
..............................
bruits de la cuillerée de pollen
..............................
..............................
..............................
..............................

L'oiseau crayon glisse au-dessus de la terre noircie, trébuche en l'air,
.............................. s'arrête, déjà jamais, se pose, ne voit personne
écrit.

oiseau crayon

..............................

feathery

..............................
..............................
..............................
..............................
..............................
..............................
..............................
..............................
..............................
..............................

frotté à la neige

..............................
..............................
..............................
..............................
..............................
..............................
..............................
..............................
..............................

enlevé à la terre

..............................
..............................
..............................
..............................
..............................
..............................

la main
l'étrangle à ses graffiti
……………………………
……………………………
……………………………
……………………………

……………………………prolifique
géraminium
……………………………
……………………………
……………………………
……………………………
……………………………
……………………………
air
air

l'oiseau-crayon
chiffonne des heures
……………………………
……………………………
……………………………

ô
……………………………
……………………………
……………………………
……………………………

lums
……………………………

..............................
..............................
..............................
..............................
..............................

à travers
l'air
indéfini

..............................
..............................
..............................
..............................
..............................

..............................

..............................

..............................
..............................
..............................
..............................

quatre gouttes de temps de lune

..............................
..............................
..............................

..............................
..............................

..............................
..............................

..............................
..............................

..............................
..............................

......................................
......................................

ni boues, ni mains, ni os, ni orbites, ni fumées, ni âmes, ni cendres,
......................................
 les morts, les morts seuls, les morts étaient là

......................................
......................................
......................................
......................................
......................................
......................................
......................................
......................................
......................................
......................................
......................................
......................................
......................................Rue sans rue, aux maisons sans maisons, aux toits sans
oits, comment la rue du passé se rapprochant, si je parvenais à lui faire faire ce
nouvement vers moi, me pourrait-elle paraître, là, maintenant, passée?
......................................
......................................
......................................
......................................
......................................
......................................
......................................
......................................
......................................
......................................
......................................
......................................
......................................
......................................

..............................
..............................
..............................
..............................
..............................
..............................
..............................
..............................
..............................
..............................
..............................
..............................
..............................
..............................
..............................
..............................
..............................pouvait-on encore parler d'une vie?

..............................
..............................
..............................
..............................
le fond de la guinness plus noire
..............................
..............................
..............................
..............................
..............................
..............................

..............................
..............................
..............................
..............................
..............................
..............................sous un arbre, s'allongeant, on verrait
le ciel confier l'infini
à

à la fureur du rose entrenoir
..............................
..............................
..............................
..............................
..............................
..............................
..............................

sourd
..............................
..............................
..............................
..............................
..............................
..............................

..............................

..............................
Tu n'as pas abouti
..............................
..............................
..............................
..............................

..............................
..............................
..............................

Dans ta tête d'une main
Tu traces la voyelle
De l'autre l'efface
..............................
..............................
..............................

.....................................
.....................................

.....................................
.....................................
morts
.................................
sur le plancher des aiguilles de pin
incessants grillons
.....................................
.....................................
.....................................
.....................................
.....................................
.....................................
.....................................
.....................................
.....................................
.....................................
.....................................
.....................................
.....................................
.....................................

.....................................
.....................................
pente légère
.....................................
.....................................
.....................................
évasive
sous l'ampoule nue
.....................................

...............................
...............................
...............................
...............................
dans le lit
chacun avait mis son amour
...............................
...............................
...............................
...............................
...............................
...............................
...............................
...............................
...............................
...............................
...............................
...............................
...............................
...............................
...............................

...............................
...............................
sur des arbres comme des langues comme des lignes
...............................
...............................
...............................
...............................
...............................
...............................

Sa mort? parfaite
Sa mort, lente, puis large, puis lourde: parfaite
...............................
...............................
...............................
...............................
...............................
...............................
...............................

Moon
Omoon

..................................
..................................

..................................
..................................
..................................
..................................
..................................

unmoon me
now
omoon

..................................
..................................

Elle rencontre l'eau
Et s'éteint

..................................
..................................
..................................
..................................

..................................
..................................
..................................
..................................

..................................
..................................
..................................
..................................
..................................

..................................
..................................
..................................
..................................
..................................

..................................
..................................
..................................
..................................

..................................
..................................

le rectangle de miroir d'une lumière de gris et de blanc et le mur
lentement s'emplissent de la lampe

..................................
..................................
..................................
..................................
..................................

..................................
..................................
..................................
..................................
..................................

..................................
..................................
..................................
..................................
..................................

..................................
..................................
..................................
..................................
..................................

..................................
..................................
..................................
..................................
..................................

..................................
..................................
..................................
..................................
..................................

..................................
..................................
..................................
..................................
..................................

..................................
..................................
..................................
..................................
..................................

Le MUR les feuilles écartées <u>le jaune</u> sur le mur Les feuilles
écartées <u>sous le jaune</u>
..................................
..................................
..................................
..................................
..................................

..................................
..................................
..................................
..................................
..................................
..................................

Le MUR les feuilles écartées le sombre sur le mur Les feuilles
écartées sous le sombre

...................................
...................................
...................................
...................................
...................................
...................................

...................................
...................................
...................................
...................................
...................................
...................................
...................................
...................................

...................................
...................................
...................................

sous le soleil?

...................................
...................................
...................................
...................................

...................................
...................................
...................................
...................................

...................................
...................................
...................................
...................................

...................................
...................................
...................................
...................................

...................................
...................................
...................................

Sous les soleils

...................................
...................................
...................................
...................................

...................................
...................................
...................................
...................................

...................................
...................................
...................................
...................................

...................................
...................................
...................................

L'éternité sans souvenir

...................................
...................................
...................................

...................................
...................................
...................................
...................................

...................................
...................................
...................................
...................................

...................................
...................................
...................................
...................................

un temps pour mourir,

...............................
...............................
...............................

...............................
...............................
...............................
...............................

...............................
...............................
...............................
...............................

...............................
...............................
...............................
...............................

...............................
...............................
...............................

Sous le soleil

...............................
...............................
...............................
...............................

...............................
...............................
...............................
...............................
...............................

...............................
...............................
...............................
...............................

...............................
...............................
...............................
...............................

...............................
...............................

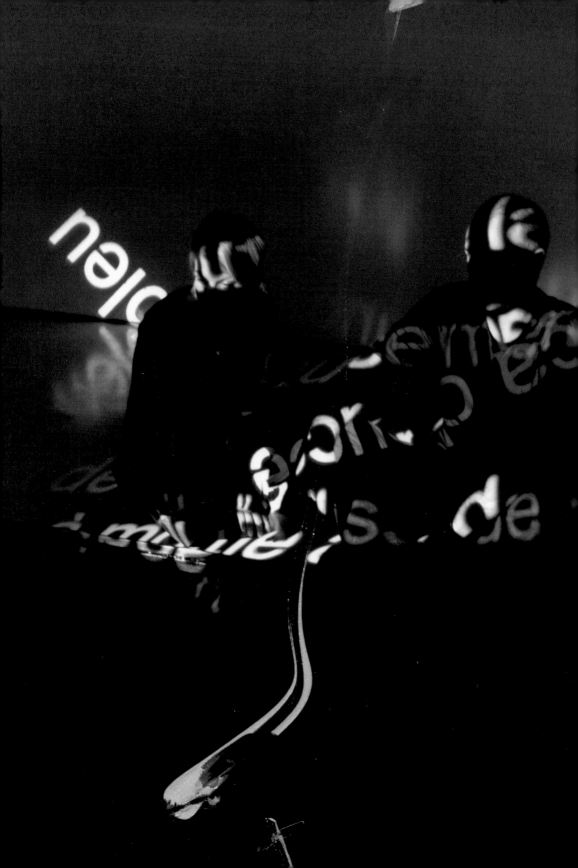

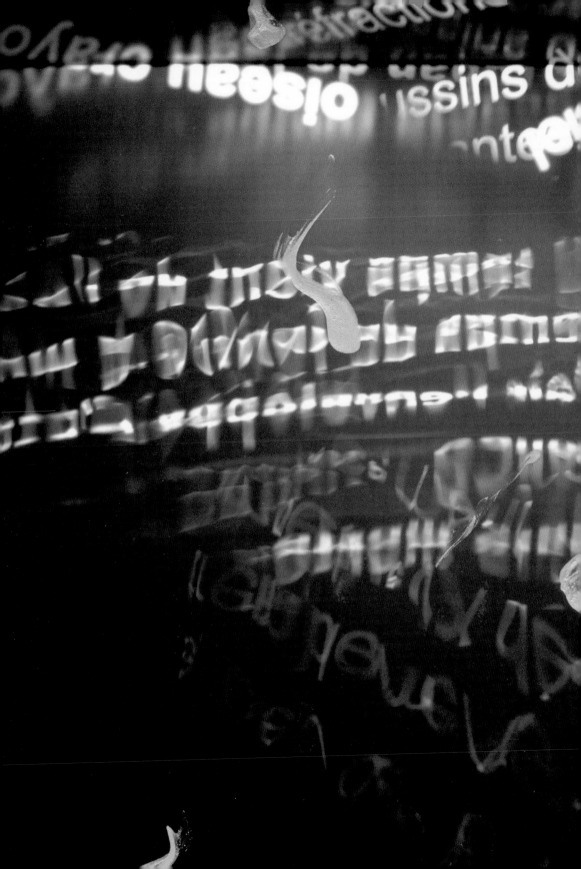

émère.

dans l'inévitable

la forme

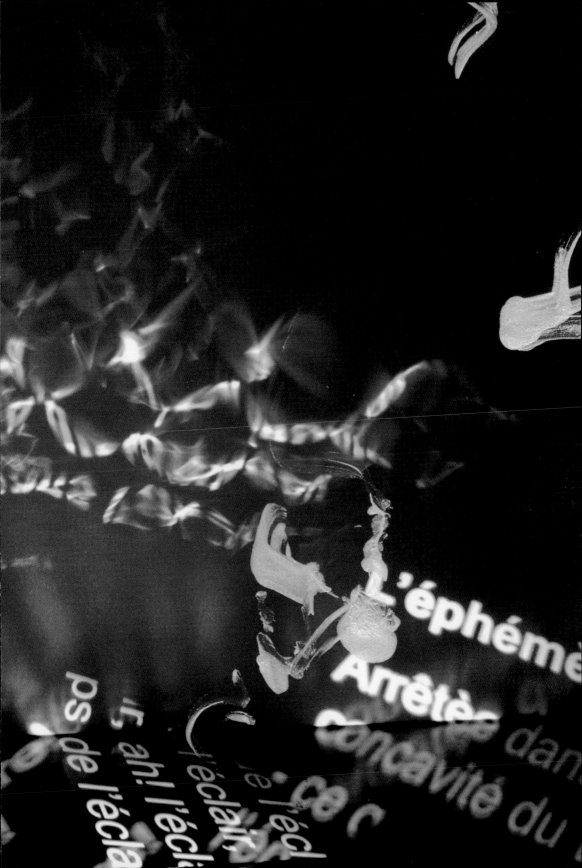

Licht gefangen im Bauch des Wales

Für ein Buchprojekt schrieb 1997 Jacques Roubaud
53 Gedichte für Rebecca Horn. Um die Zeichen
für neue Zeichnungen entstehen zu lassen, entwickelte
Rebecca Horn Lichtskulpturen, die diese Texte
projizieren. Sie wandern und durchdringen den
dunklen Raum, bilden ein verschlungenes Netzwerk,
ein Textfirmament. Reflektiert durch das schwarze
Wasserbad entstehen neue Zeichen. Man wird selbst
in diesem Raum Teil dieser Auflösung des Schreibens
neuer Lichtzeichen. Ein Dialog-Gesang, komponiert
und gesungen von Hayden Danyl Chisholm, begleitet
diesen Prozess.

Horizontale Wurzeln,
Verästelungen der Kiemenflügel
gesäugt durch kaltes Blut.
Unendlich allein in den schlüpfrigen Gängen.
Luftgestalten, Mondgestalten
Wo sich fließend festhalten?
Den Körper reibend ein Feuer entfachen,
im Hotel der ungeborenen Worte,
Bessie Love in Paris, 1928

In der Nacht wandern die Worte
wie Schatten im Innern des Kopfes,
gleiten über den Marmor des Wassers.
Ein goldener Stab unterbricht das Fließen,
schreibt gegenläufig ins schwarze Wasser,
erlöst in den Wellen die Sätze,
entfacht einen Taumel der Zeichen
in verspiegelter Transparenz.
Zitternd ordnen sich Worte neu,
den Mond um Orientierung fragend,
in der Kuppel des Wortgeflechts.

Flucht aus dem Bauch verflochtener Echos.
Den Herzpuls des Wals umkreisen.
Mein Schatten erfindet sein Fieber,
umklammert das kalte Pochen,
schickt Flammen des Lichts
zur Mitte des Herzens.
Ungewiss, ob Liebe die Befreiung im Feuer birgt.

Das Samenkorn des Wortes
im Dunkeln genährt
unentschieden den Herzknoten zuknüpfen
ist Licht und Schatten zugleich
freischwebend.
Ein Tropfen von Wasser und Luft
formt sich im Innern des Wals
zu einem Schrei.
Geburt des Wortes,
dessen Schall über den Wellen
der Sonne entgegengleitet.

REBECCA HORN

WITH SPECIAL THANKS TO

Jacques Roubaud
Hayden Danyl Chisholm
Catherine Thieck
Yvon Lambert
Joachim Sartorius
Timothy Baum
Doris von Drathen
Peter Weyrich
Karin Weyrich
Harald Müller

MUSIC COMPOSED BY HAYDEN DANYL CHISHOLM

Musicians

Gareth Lubbe	Overtone voice, violin
Tom Manoury	Overtone voice, bells
Hayden Danyl Chisholm	Overtone voice, flute
Liesel Jürgens	Soprano
Claudio Bohorquez	Cello
Adrian Brendel	Cello
Petar Avramovic	Mixing

This piece was created for the installation by
Rebecca Horn "Lumière en prison dans le ventre
de la baleine", using material collected over
the last few years.
Special thanks to Gareth Lubbe for the use of
his recordings from a Slovenian monastery and
to Petar Avramovic for help editing the tapes.